max ernst

ernst

Text by
PAMELA PRITZKER
Layout design by
JACQUES DOPAGNE

SPURBOOKS LTD
LONDON

Published by
SPURBOOKS Ltd
LONDON, 1975
ISBN 0.902875.97.3
© 1975 SPADEM
Printed in Italy

For almost three-quarters of a century, the work of Max Ernst has consistently remained vitally important to 20th century art. Often affiliated with Dada and Surrealism, Ernst has created a separate and unique identity above and beyond any style or movement. His distinct visual imagery is fierce, sarcastic, disturbing, bizarre and always perplexing. But his works never lack passion nor do they ever fail to evoke a new sense of awareness. Each work explores a new, previously hidden reality. It is this freshness and vitality which make the works of Max Ernst a powerful and driving force in contemporary art.

Ernst was born in 1891 in a small town near Cologne. His family was intensely religious and

his upbringing was extremely rigid. His father, Philip, taught in a school for the deaf and dumb and was also an amateur painter of religious and nature subjects. However the kind of painter his father was, would eventually be the antithesis of what Ernst was to become. Once his father was painting a scene outside their house, when he decided that a certain tree did not suit the composition and therefore he eliminated the tree from the painting. Next, he wondered if perhaps the real tree itself should not also be removed from the garden. This type of reaction caused Ernst to question if something was missing in the relationship between the artist and subject matter; a query which was to remain in all of his future works.

The childhood events in Ernst's life would continue to have a tremendous impact on his later works. At the age of six, suffering from a high fever, Ernst experienced hallucinations,

which he claims "were provoked by the suggestive designs on an imitation-mahogony panel opposite his bed..."

These he later produced at will by staring into space, walls, clouds, etc. Visually precocious, young Ernst began to experiment with patterns and designs which would later stimulate his discoveries of collage and frottage. Once asked what he enjoyed doing most in his life, Ernst replied, "Looking." Other events, of a more traumatic nature would also tend to erupt in his later paintings, especially those which he could attempt to solve through the psychoanalytic methods of Freud. One in particular is exceptionally revealing. On a night in 1906, Ernst discovered that Hornebom his beloved pet cockatoo was dead. Suddenly, his father announced that his sister Loni had just been born. This bizarre coincidence threw Ernst into a prolonged emotional state, frequently

La Femme 100 Têtes (Collage)
Loplop
et l'horoscope de la souris
1929

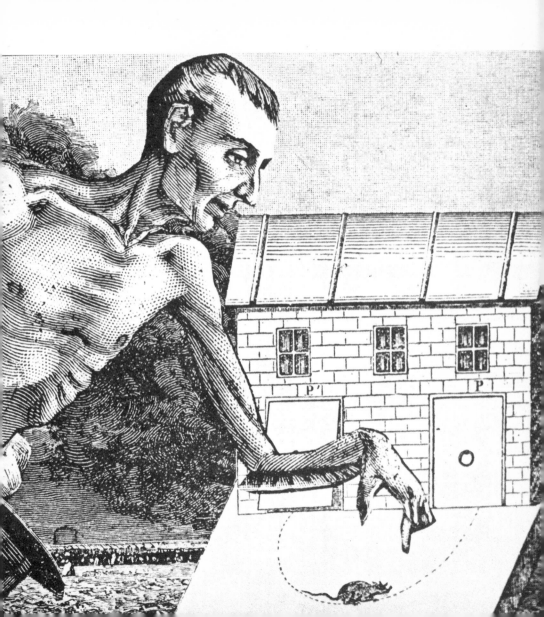

confusing humans and birds. Almost twenty-
five years later this trauma would be visually
manifested in Ernst's painting of his alter ego,
"Loplop, Superior of the Birds."

Although Ernst had been exposed to painting
throughout his childhood, it was not until he
was a student of philosophy at the University
of Bonn that he began to paint. He found
himself drawn to the expressionist works of
Van Gogh, Gauguin, Matisse and Kandinsky.
In 1911, he joined the Young Rhineland Group,
formed by August Macke which brought him
into contact with the progressive artists of
France and Germany. The following year he
exhibited his works in Berlin, along with
Kandinsky, Macke, Klee, and Chagall. In 1913,
he was introduced to Delaunay and Apollinaire
and for the next year his work vascillated between
many contemporary movements, yet he did not
associate himself with any one group.

The outbreak of WWI, in August 1914, broke the complacent bubble of European society. Ernst enlisted in the army with the irresolute knowledge of the horrors which lay ahead. Those four years of war for Ernst were as if he "died on the 1st of August 1914" and "resuscitated on the 11th of November 1918 as a young man aspiring to become a magician and to find the myth of this time".

Young, angry, outraged and full of enormous pent up energy from the War, Ernst became involved with the one group who could possibly present an outlet for these passions: Dada.

His entry was marked by the founding of the "Dada Conspiracy of the Rhineland", whose goal was to attack and subvert the political establishment in Europe which had allowed W.W.I. to reign for five hideous years of wanton destuction. Dada was not an art style, but a lifestyle; an expression of disgust and

La Femme 100 Têtes (Collage)
Perturbation ma sœur
1929

La Femme 100 Têtes (Collage)
La même, pour la deuxième
1929

indignation whose goal was "nothing less than total subversion" (Max Ernst, 1871).

In 1919, Ernst and his old friend Baargeld, (a pseudonym for Alfred Grünewald whose father was a Cologne banker) began to publish numerous Dada journals, including, *Der Ventilator, Bulletin D* and *Die Schammade.* They attacked the political and social establishment through insulting and sarcastic visual and literary imagery. According to Ernst the works, "were not meant to be appealing; they were meant to make people howl!" In 1920 Hans Arp, another old friend of Ernst, joined the Conspiracy and together they held the infamous Cologne International Dada Exhibit in a men's urinal.

Dada brought to the art world drastic changes in subject matter and technique. Most of these changes were initiated by Marcel Duchamp, one of the most prolific Dada artists. He employed three basic principles in his art:

1. Movement and the Mobility of the Machine: He took the machine and rendered it an art object.

2. Chance, Accident and Irony: Through which the unconscious could be expressed and realized.

3. The Object: As in Duchamp's ready-mades, the object was virtually endowed with a personality. Ernst became enthralled by Duchamp's ready-mades and the comical mechanical drawings of Francis Picabia. He then discovered a fascination with mechanical catalogues. It was in the extremely scientific and rational catalogues that Ernst suddenly perceived "elements of figuration so remote that the sheer absurdity of that collection provoked a sudden intensification of the visionary faculties in me and brought forth an hallucinatory succession of contradictory signs..." These "contradictory signs" became the elements of collage. At first they were additions of a line

La Femme 100 Têtes
Suite. (Collage)
1929

or a dash of color which Ernst envisioned within
himself during the hallucinations. However,
soon Ernst began to cut out and reassemble the
drawings into incongruous and haunting com-
positions. His collages were not the cut and
paste type of the Cubists because he was not
primarily concerned with the plasticity of the
image, but in how the image provokes the
unknown, inner world. His collages force the
exterior real world to confront the hidden reality
of the unconscious. They create a multiplicity
of associations by giving form to the new reality
of dreams and the unconscious as presented by
Freud. Ernst has forced the viewer to expand
beyond the rational and logical waking world
into the world of fantasy, dreams and illusion.
By rearranging traditional schemata, placing
the familiar image into a new and strange context,
he forces the observers to retune their old defi-
nition of visual reality and to reconcile the

La Femme 100 Têtes (Collage)
L'immaculée conception
1929

exterior and public world with the interior and private world of the unconscious. Ernst stated that the collage is "a meeting of two distant realities on a plane foreign to both." Thus, visually Ernst attempted to reconcile the two equal parts of our existence and turn them into a new and complete reality.

During the year 1921, Ernst returned to painting large-scale compositions resembling his earlier collages. The subject matter and technique resulted in disturbing images anticipating the coming of Surrealism. By the time Paul Eluard, the leading Surrealist poet, visited Ernst in Cologne, we can see Ernst moving away from Dada in his painting "The Elephant Celebes". Ernst became immersed in visually manifesting the world of dreams and the unconscious. He drew upon the memories of his childhood traumas as subject matter and tried to resolve them through the psychoanalytic

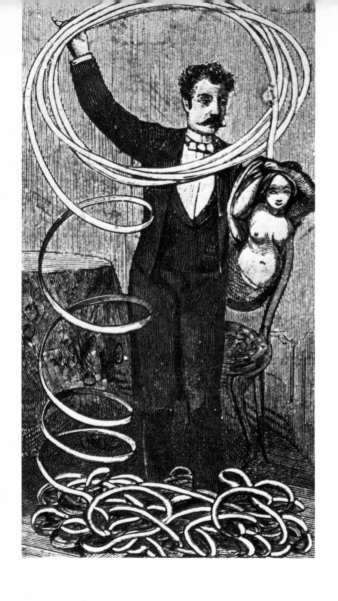

La Femme 100 Têtes (Collage)
Sorcellerie ou quelque farce macabre·
1929

La Femme 100 Têtes (Collage)
Alors je vous présenterai l'oncle

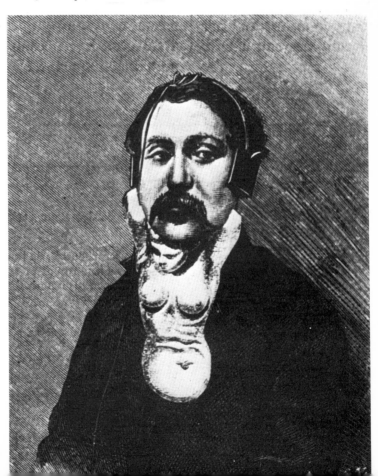

methods of Freud. By using De Chirico's methods of varying perspectives rather than the traditional method of one-point perspective, he created a twilight zone setting in which his memories existed. At the end of 1921, Ernst left Cologne for Paris, ending the Dada activities. In 1923, Ernst decorated the walls of his house with strange and flamboyant frescoes. It was at this point that he truly entered into the world of Surrealism. In 1924, André Breton published the first Surrealist manifesto. Max Ernst's work became the visual counterpart, taking the ideas of Surrealism beyond rhetoric and theory. He enhanced Surrealism with acute sensitivity which caused him to stray from the rigid manifestos calling for "pure psychic automatism". This meant that the artist should not exert any control over his works, they should be allowed to flow from the unconscious without any aesthetic modifications by the artist.

Ernst was not able to turn himself into just a "recording apparatus" for the unconscious, he needed to express the images that were psychically perceived. It is in his expressive qualities that we see an artist transcending the movement into his own unique imagery.

At the end of 1924, Ernst discovered a new method of automatism, based on frottage or rubbing technique. While staring at a wooden floor, Ernst was suddenly provoked by the pattern created by the grain. This reaction was very similar to the one he had as a child caused by the "imitation mahogony panel" and the result of the inspiration was the frottage. Ernst began lead rubbing on paper placed on the floor. The patterns and designs, created by the accidental and random grain of the wood became the very interesting works such as "The Ego" and "His Won." This technique led to the "scraping" or "grattage" method, which

resulted in the series of the "Rose Doves" and "To 100,000 Doves".

For the next twenty years, Ernst concentrated on developing and exploring various themes and symbols. In a sense, he created his own private mythology out of his own fears and anxieties. Birds, cages, eggs, and creature-like people became the main characters in his attemps to explore and resolve the mysteries of his own psychic awareness. In 1930, Ernst's obsessive interest in birds is culminated in "Loplop, Superior of the Birds", his painting of his alter ego. This presents the resolution of Ernst's earlier trauma caused by the death of his pet cockatoo coinciding with the birth of his sister. Throughout this period his forests, landscapes, animals and beasts possess a horrible foreboding sense of no return. They confront us with the unknown and an inescapable feeling of fear.

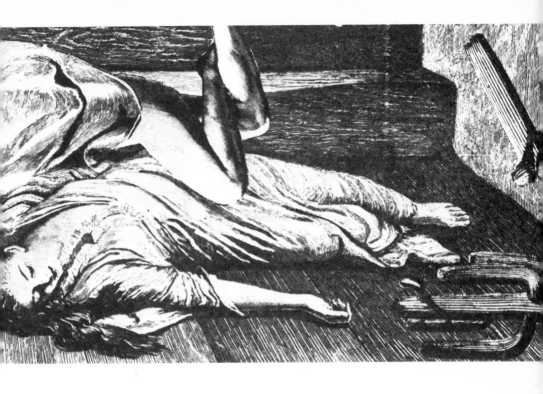

La Femme 100 Têtes (Collage)
Ouvre sa manche auguste
1929

Une Semaine de Bonté
Collage
1934

By this time Ernst had produced numerous single collages and finally published his first collage-album, *La Femme 100 têtes* (Hundred-headed woman). The heroine is "Perturbation, my sister, the 100-headed woman" who appears throughout the novel in statuesque nudity. Ernst portrays the hero as "Loplop, Superior of the Birds" and provokes a variety of situations to please "Perturbation". It is in this album that we most clearly see the underlying humor in his works. Through this sarcasm, which is directed at us all, Ernst attempts to resolve the fear of the unknown.

By 1939, Europe was again in the throes of its second political and social upheaval of the century: World War II. In that year, Ernst was interned in France twice. The first time as an enemy alien, then under the German occupation of France as an undesirable. During the last

Une Semaine de Bonté
Collage
1934

internment Ernst and Hans Bellmer together
began to experiment with the method of
Decalcomania, created four years earlier by
Oscar Dominguez. In this technique, a thin
layer of paint is pressed onto the canvas surface
by a smooth object, spreading the paint in
varying degrees of thickness and form. Ernst
continued to employ this method as a basic
starting point for his work to which he would
add meticulously painted forms and figures.

In 1941 Ernst managed to escape from France
and joined the many other exiled artists in
New York. One year later Ernst painted, "Sur-
realism and painting" in which he turns his
black, biting humor against himself and his
own goals as a Surrealist painter.

After World War II and following his rejection
of Surrealism, Ernst returned once more to
large-scale painting. He explored many new
methods and techniques, including drip painting

which was to become the trademark of Jackson Pollock by the 1950's... However, he soon exhausted all of the new and old methods which he had been the first to introduce. By 1953, Ernst was living in the Southwest of the United States and became increasingly absorbed by the natural environment. He began to paint landscapes the likes of which have never been seen again. He started a passionate love affair with color which he manipulated to express his own wonder and amazement with nature. At a time when the earlier works of Ernst and all of the Dada and Surrealist artists were being critically and historically accepted, Ernst turned away from the concepts of anti-art. From the early 1950's until the present, the paintings of Ernst have radiated a magnificent life force. Although the sense of foreboding is still hinted at in these later works, a vital love for life remains their all encompassing power.

BIOGRAPHY

April 2, 1891
Max Ernst is born in Brühl, a small Rhineland town.

1908-1914
Enrolled as a liberal arts student at the University of Bonn, Max Ernst turns to painting and reads the philosophers and the poets. His friendship with Macke, Henseler and the poet Kühlemann dates from this time.

His meeting with Apollinaire at Macke's makes a big impression on him. A short trip to Paris. He meets Arp in Cologne (1914) and a lifelong friendship is formed.

1914-1917
The war, "for three trifles: God, Emperor and Country." While mobilized, Max Ernst takes advantage of his rare moments of leisure to paint watercolors, most of which have been lost or destroyed.

1918
Max Ernst's marriage to Louise Strauss. A son, Jimmy, who is now a painter. After demobilization, Max Ernst stays in Cologne, where a Dada House opens. He is in contact with subversive groups in Munich, Berlin and Zurich.

1919
He meets Paul Klee in Munich; publication of *Fiat Modes: Pereat Ars*, a series of eight lithographs in homage to de Chirico; first collages.

1921
A letter from André Breton, evidence of the Parisian Dadaist's interest in Max Ernst, proposes an exhibition in Paris. The show is held later in the year at the "Au Sans Pareil."

1922
Paul Eluard buys *The Elephant of the Celebes* and *Oedipus Rex* from Max Ernst. Publication of *Les Malheurs des Immortels*, a joint production by Max Ernst and Paul Eluard. Max Ernst settles in Paris. He lives with the Eluards in Saint-Brice and Eaubonne for a year and a half; he decorates the Eaubonne house with mural paintings.

1923
Exhibits in the Salon des Indépendants; painters and writers show their sympathy with Max Ernst; the interest of collectors is awakened (the Düsseldorf Kunsthalle buys *La Belle Jardinière* the following year).

Max Ernst sells his Paris canvases to a Düsseldorf coffee-shop proprietor, "Mutter Ey."

1924
André Breton publishes his first *Manifeste du Surréalisme*.

1925
Max Ernst manages to rent a studio. An agent, Jacques Viot, signs a contract with Arp, Miró and Ernst. First frottages; collected in *Histoire Naturelle*, they are published by Jeanne Bucher the following year.

1926
First important Paris show at the Van Leer Gallery; the Jeanne Bucher Gallery exhibits the plates from *Histoire Naturelle*; Max Ernst and Miró collaborate on the settings and costumes for Diaghilev's ballet *Romeo and Juliet*.

1927
Year of the "visions," done by grattage, a technique similar to frottage.

Max Ernst marries Marie-Berthe Aurenche.

1929-1930
The first collage novel, *La Femme 100 Têtes*, is published, followed in the same year by *Rêve d'une Petite Fille Qui Voulut Entrer au Carmel* (Editions Carrefour). Loplop makes his first appearance.

1932-1933
Max Ernst is blacklisted by the Nazis.

1934
Jeanne Bucher publishes *Une Semaine de Bonté*, a new collage novel.

1935-1936
Max Ernst participates in the exhibition "Fantastic Art, Dada and Surrealism" organized by the New York Museum of Modern Art. Like Dominguez, Max Ernst applies the decalcomania process to oil painting.

1937
Special number of *Cahiers d'Art* devoted to Max Ernst ("Au-delà de la Peinture"); settings for Jarry's *Ubu enchaîné*.

1938-1941
Max Ernst breaks with André Breton and the Surrealist group. Max Ernst settles in Saint-Martin d'Ardèche, near Avignon.

In 1939 Max Ernst is interned as a German alien, going from a detention house in Largentière to one in Milles. Set free for Christmas, he returns to Saint-Martin-d'Ardèche, only to be arrested again. He escapes with the Gestapo after him. Max Ernst manages to get to the United States, arriving on July 14, 1941. He is again arrested as a German alien, but is freed three days later. Marriage to Peggy Guggenheim.

1943
He meets Dorothea Tanning and moves to Sedona, Arizona with her.

1944-1945
On May 8, 1945, the day the Third Reich collapses, Max Ernst's exhibition at Julien Levy's in New York opens.

1946
Max Ernst paints the *Microbes*, minute canvases accompanied by poems. They are published seven years later by the Cercle des Arts under the title *Sept Microbes Vus à Travers un Tempérament.*
Double wedding in California: Dorothea Tanning and Max Ernst, Juliet Browner and Man Ray.

1947
Mural sculptures, the *Capricorn* group. In Paris, Pierre Seghers publishes Eluard's prose poems "illustrating" somes old collages by Max Ernst: *A l'Intérieur de la Vue: Huit Poèmes Visibles.*

1948
"Beyond Painting" published. Max Ernst becomes an American citizen.

1949
Retrospective at the Copley Gallery in Beverly Hills and publication of a collection of collages and poems, *At Eye Level: Paramyths.*

1950
Max Ernst returns to Europe; reunion with his old friends. Big exhibition at the René Drouin Gallery (works from the American period).

1952
Tanguy and Kay Sage visit Max Ernst in Sedona. He gives a series of lectures at the University of Hawaii.

1953
Max Ernst and his wife move to Paris. William

Copley lends him a studio in the impasse Ronsin. E. Beyeler, Basel, publishes *Hirondil-Hirondelle*, a poem illustrated with eight etchings.

1954

The Twenty-seventh Venice Biennale awards Max Ernst the Grand Prize for Painting.

1955

Max Ernst and Dorothea Tanning move to Huismes, in Touraine. Publication of Antonin Artaud's *Galapagos* with etchings by Max Ernst.

1957

Max Ernst receives the Nordrhein-Westfalen Grand Prize for Art.

1958

Patrick Waldberg's biography of Max Ernst is published by J. J. Pauvert. Max Ernst becomes a French citizen.

1959

Retrospective at the Paris Museum of Modern Art. National Arts and Letters Prize.

1960

Publication of *Propos et Présence* (Paris, Editions d'Art Gontier-Seghers).

1962

Exhibition at the Iolas Gallery in New York and at the Wallraff-Richartz Museum in Cologne.

1963

Same exhibition at the Zurich Kunsthalle. Der Spiegel Gallery, Cologne, presents the first German translation of *Les Malheurs des Immortels.*

1964

Publication of *Maximiliana ou l'Exercice Illégal de l'Astronomie*, cryptograms and etchings commemorating the life and work of the unsung astronomer and poet, Wilhelm Leberecht Tempel. Le Pont des Arts Gallery presents *Les Chiens ont Soif*, a series of lithographs with a text by Jacques Prévert. Max Ernst and his wife settle in Seillans in the South of France.

1965

Series of *tableaux-collages* exhibited at the Iolas Gallery: *Le Musée de l'Homme*, followed by *La Pêche au Soleil Levant.*

1966

Illustrations for Lewis Carroll's *Logique sans Peine* (Paris, Hermann).

1967

Paramythes, a collection of collages and poems, published by Le Point Cardinal.

1968

Settings for the ballet of Olivier Messiaen and Roland Petit, *Turangalila*, staged by the Paris Opera.

1969

Journal d'un Astronaute Millénaire (Iolas Gallery). André-François Petit presents the mural paintings that he was able to save from Eluard's house in Eaubonne. *Dent Prompte*, poems by René Char and color plates by Max Ernst published by Le Pont des Arts Gallery.

1970

Ecritures (Le Point du Jour, N.R.F.).

1971

Lucie Weill publishes Patrick Waldberg's *Aux Petits Agneaux* with 19 original lithographs.

In compiling this information, we have referred to the very complete biographical notes given in the first part of Ecritures *(Le Point du Jour, N.R.F., 1970).*

Une Semaine de Bonté
Collage
1934

LIST OF PLATES

26 Petrified City 1937
City Art Gallery, Manchester

27 Sand Dial
Private Collection, Paris

28 Forest 1925
Private Collection, Paris

29 Collage 1931
Private Collection, Paris

30 Le facteur Cheval 1932
Peggy Guggenheim Foundation, Venice

31 Woman, Old Man and Flower 1924
Museum of Modern Art, New York

32 Pieta or Revolution at Night 1923
Roland Penrose Collection, London

33 Europe after the Rain 1942
Hartford (Connecticut) Wadsworth
Atheneum

34 Long Live France
Private Collection, Cannes
(Photo J. Hyde)

35 "La Carmagnole de l'Amour"
Private Collection, Cannes
(Photo J. Hyde)

36 . Napoleon in the Desert 1941
Museum of Modern Art, New York

37 The Antipope (detail) 1942
Peggy Guggenheim Foundation, Venice

38 The Bride of the Wind 1927
Private Collection

39 Henri IV, the Lioness of Belfort,

a Veteran 1935
Private Collection, Paris

40 Two Nude Girls 1926
Simone Collinet Collection, Paris

41 Zoomorphic Couple 1933
Peggy Guggenheim Foundation, Venice

42 The Horde 1927
Stedelijk Museum, Amsterdam

43 The Angel of Hearth and Home 1935
Private Collection, Paris
(Photo J. Hyde)

44 The Interior of Sight (Egg) 1929
Private Collection, Paris

45 The Garden of the Hesperides 1936
Private Collection, Paris
(Photo J. Hyde)

46 The Entire City 1937
Private Collection, Paris

47 Fishbone Forest 1927
Private Collection

48 Painting for Young People 1943
Private Collection, Paris
(Photo J. Hyde)

49 The Nymph Echo 1936
Private Collection, Paris

50 Temptation of St-Anthony 1945
Private Collection, Paris

51 The Nymph Echo 1936
Museum of Modern Art, New York

52 The Polish Horseman 1954

PLANCHES

PLATES

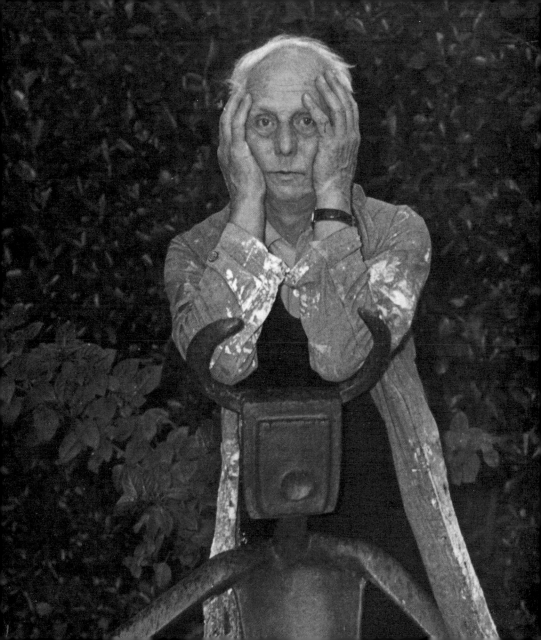

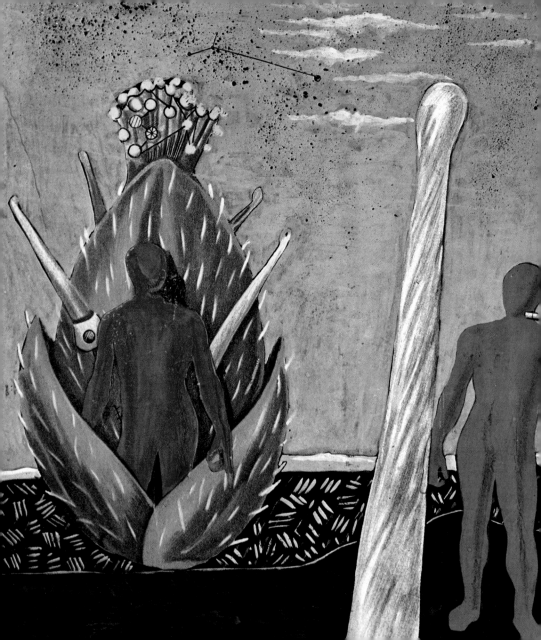

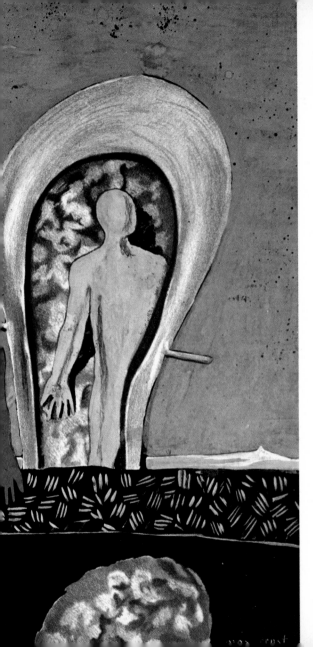

2
Dada-Gauguin
1920

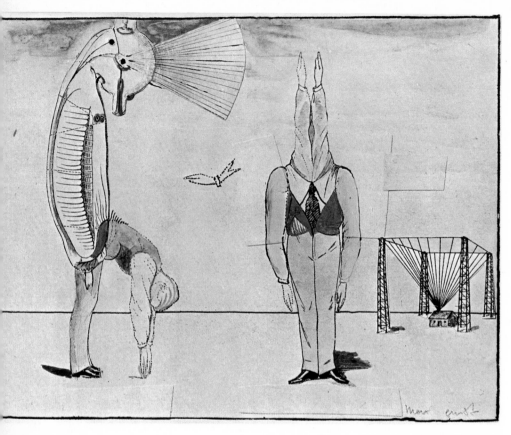

3
L'arrivée des voyageurs
1922
The Arrival of the Travelers

4
Catherine ondulée
1920
Katharina Ondulata

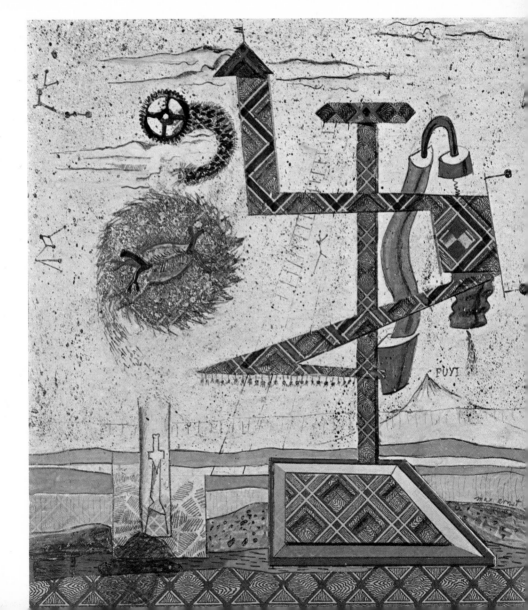

FUYI

max ernst

5
Aux 100.000 colombes
1926
100.000 Doves

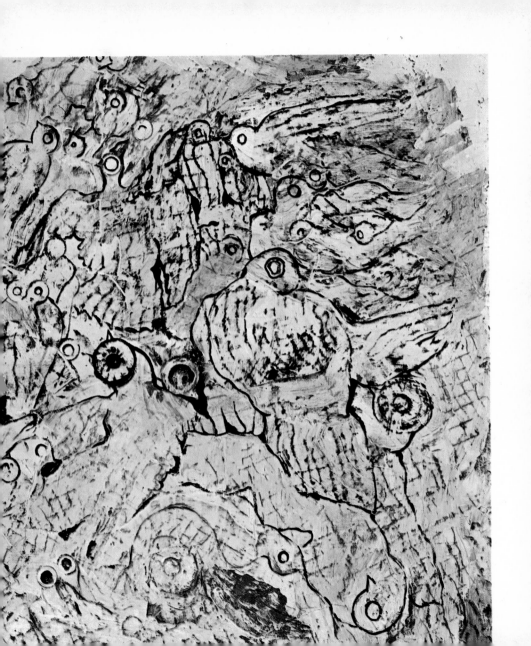

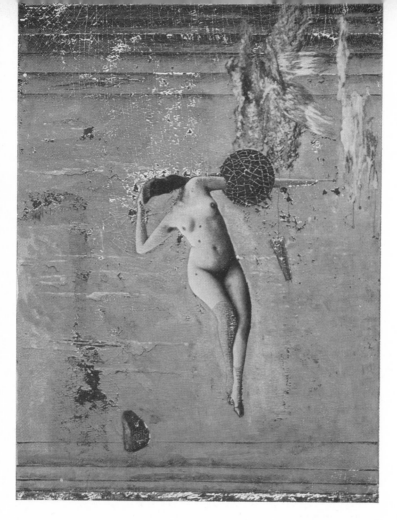

6
Les Pleïades. 1920
The Pleïades

7
L'éléphant Célèbes. 1921

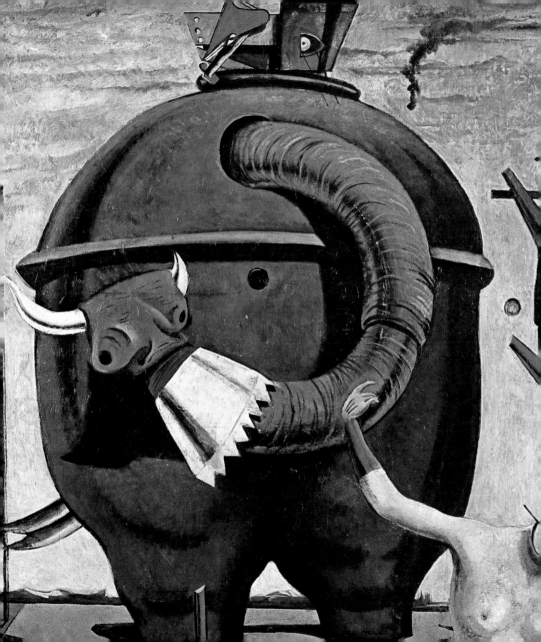

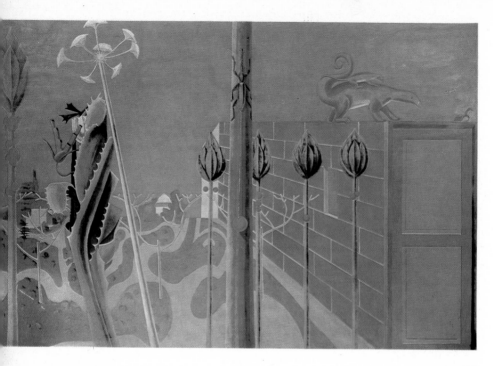

8
Histoire naturelle
1923

9
Les hommes n'en sauront rien
1923
Of This Men Shall Know Nothing

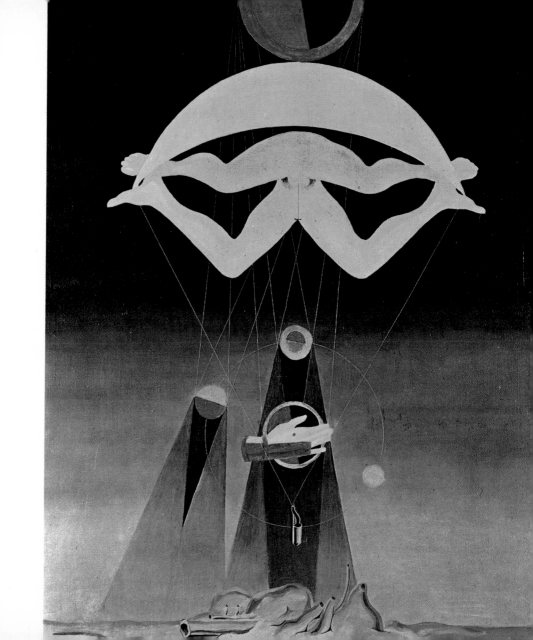

10
C'est le chapeau qui fait l'homme
1920
The Hat Makes the Man

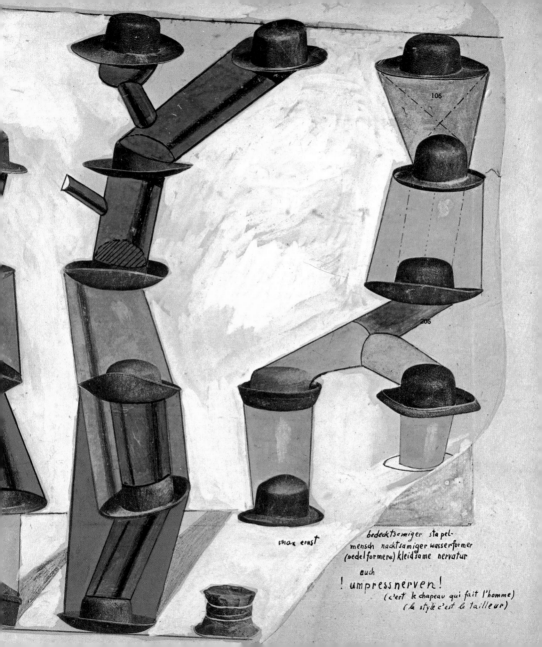

106

206

max ernst

bedecktsamiger stapel-
mensch nacktsamiger wasserformer
(aedelformer) kleidsame nervatur

auch

! umpressnerven !

(c'est le chapeau qui fait l'homme)
(le style c'est le tailleur)

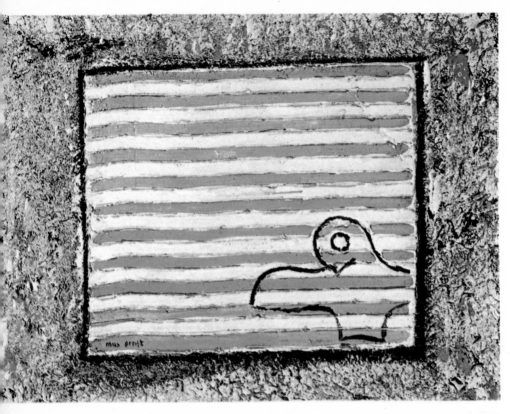

11
Oiseau en cage
1927
Caged Bird

12
L'oiseau avait raison. 1926
The Dove was Right

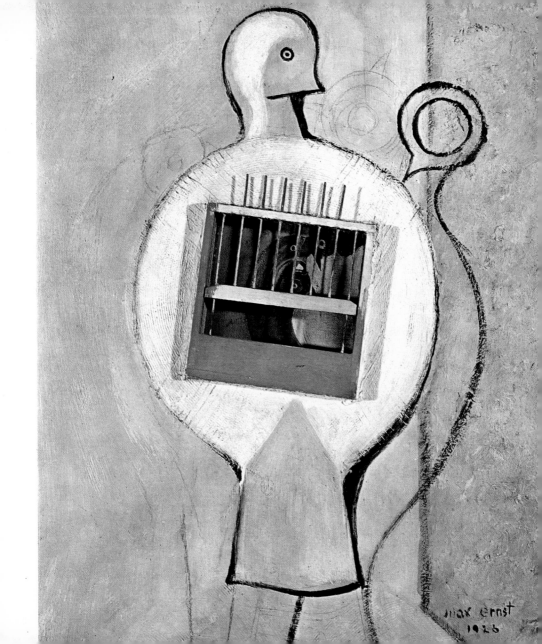

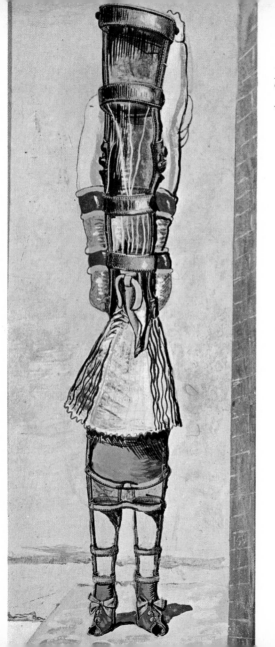

13
Jeune chimère
détail
1920
Young Chimera

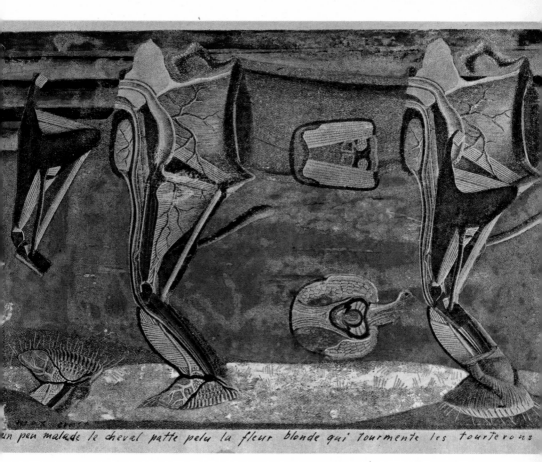

14
Un peu malade le cheval...
1920
The Horse, He's Sick

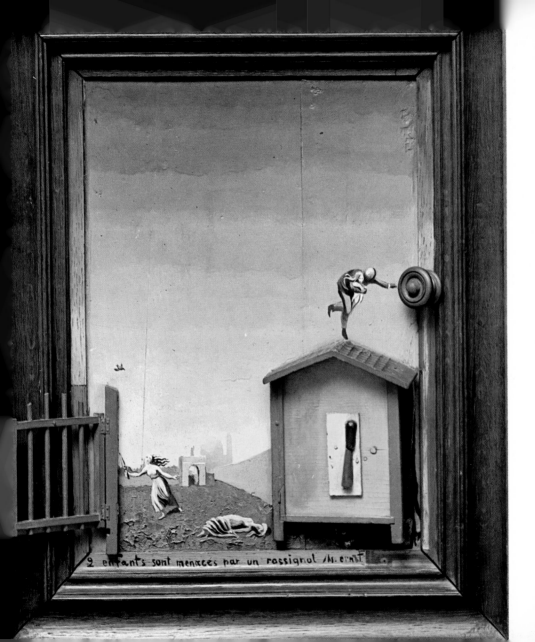

2 enfants sont menacés par un rossignol /M. ernst

15
Deux enfants menacés
par un rossignol
1924
Two Children are Threatened
by a Nightingale

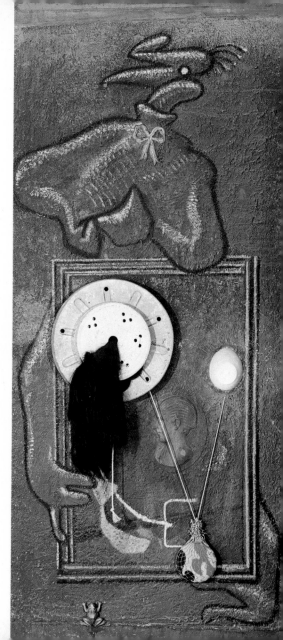

16
Loplop présente
une jeune fille
1936
Loplop Introduces
a Young Girl

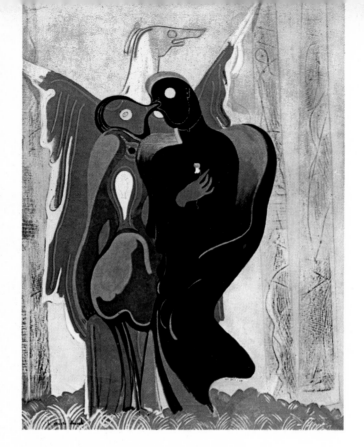

17
Le chaste Joseph
1927
Chaste Joseph

18
Oedipus Rex
1922

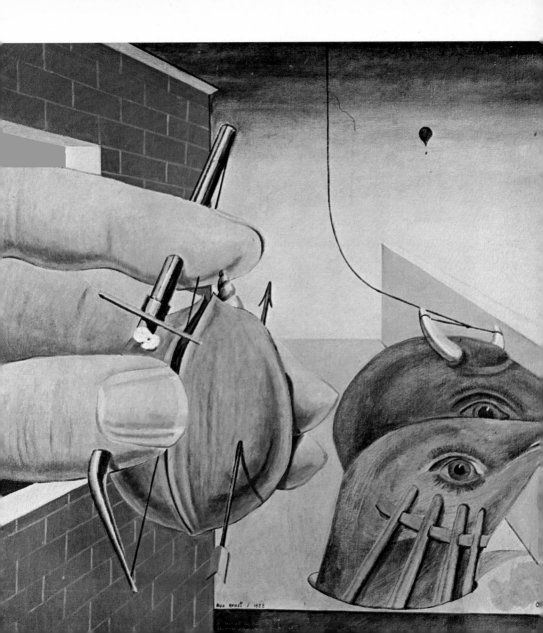

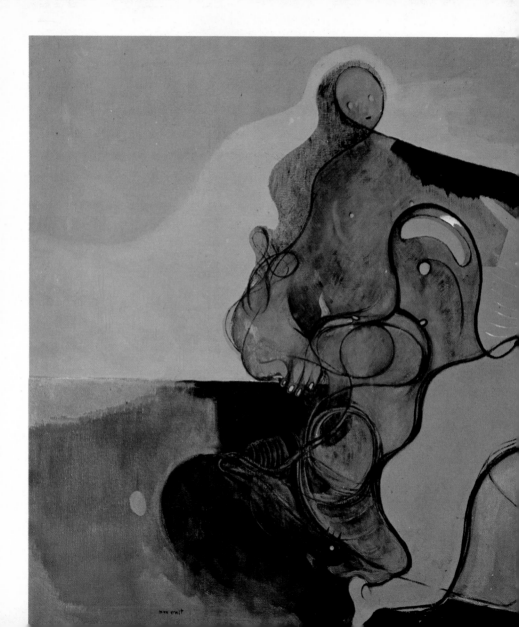

19
Le baiser
1927
The Kiss

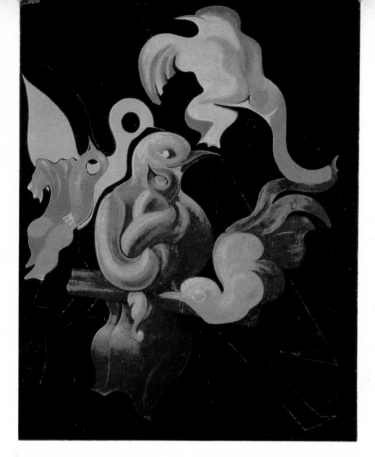

20
Après nous la maternité
1927
After us-Motherhood

21
Unknown Title
1921

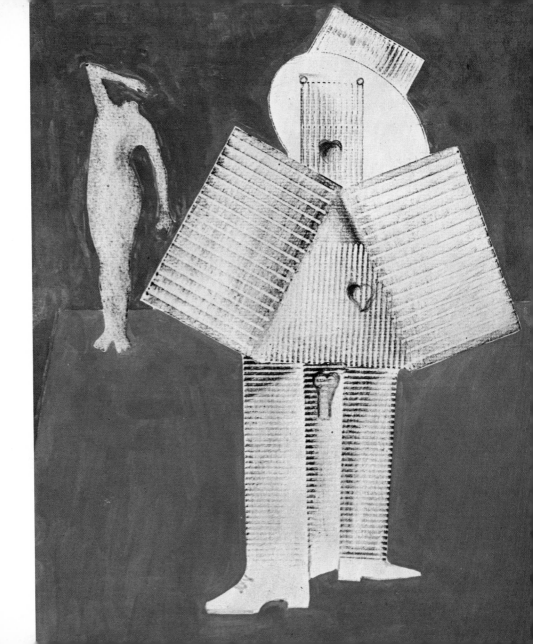

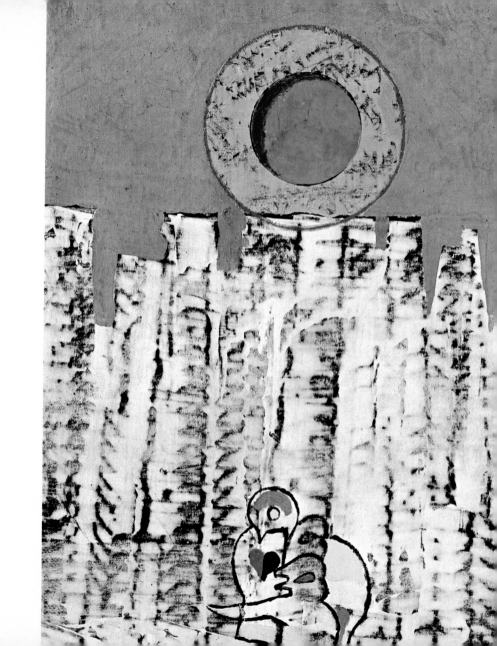

22
Forêt, soleil et oiseaux. 1928
Forest, Sun and Birds

23
Paris rêve. 1925. Paris Dreams.

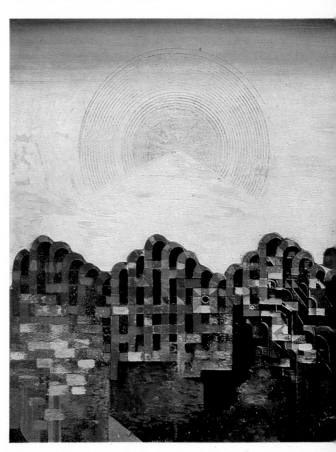

24
La grande forêt
1927
The Great Forest

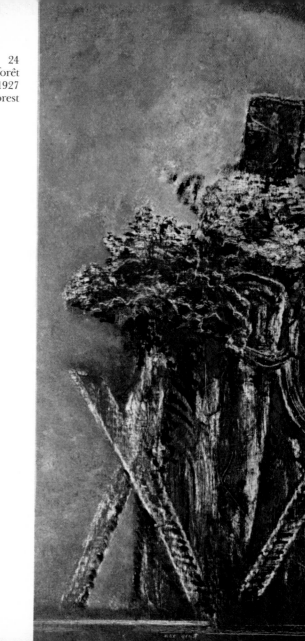

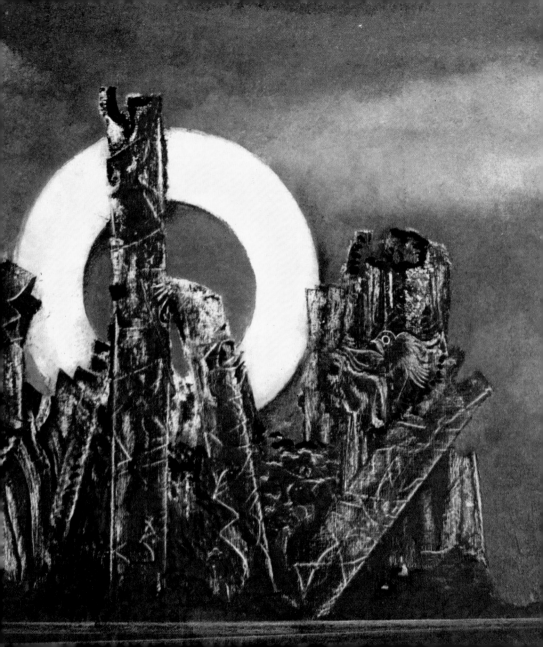

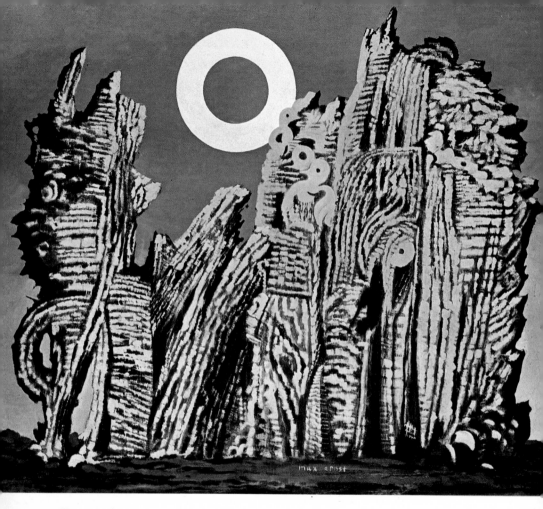

25
La forêt grise. 1926
The Grey Forest

26
La ville pétrifiée
1937
Petrified City

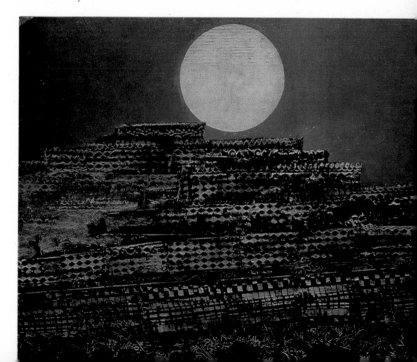

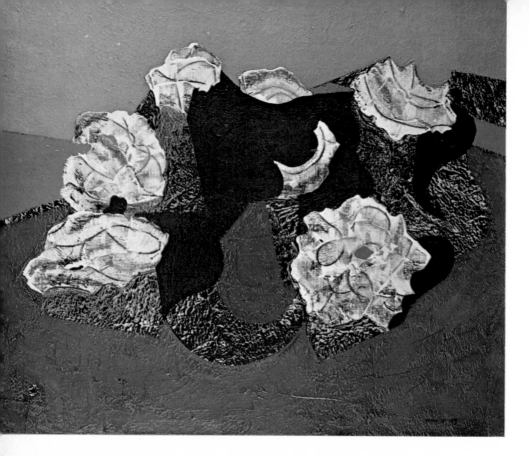

27
Rose des sables
Sand Dial

28
Forêt. 1925
Forest

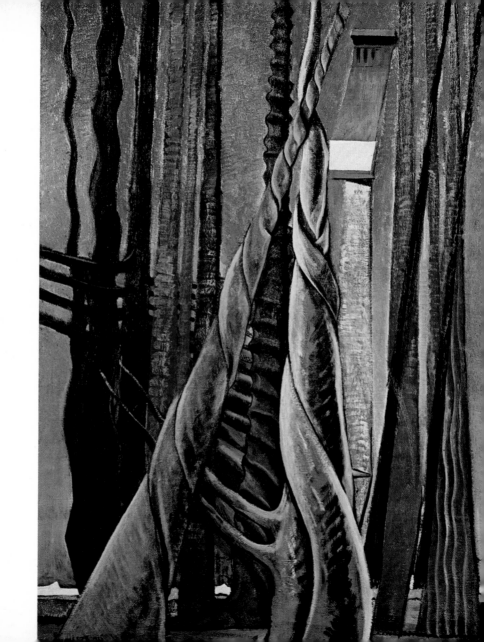

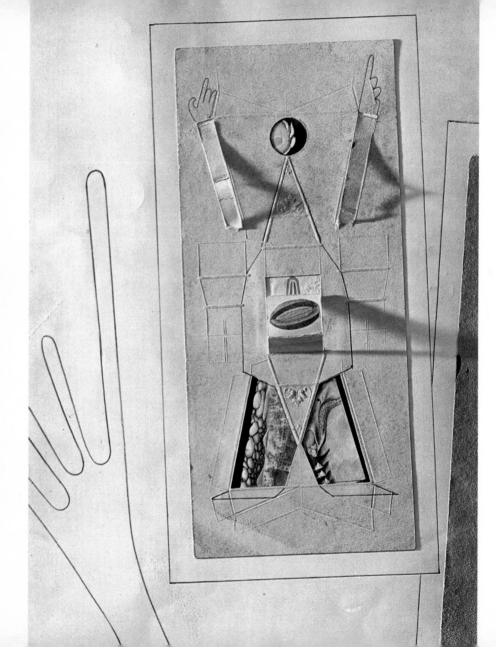

29
Collage
1931

30
Le facteur Cheval. 1932

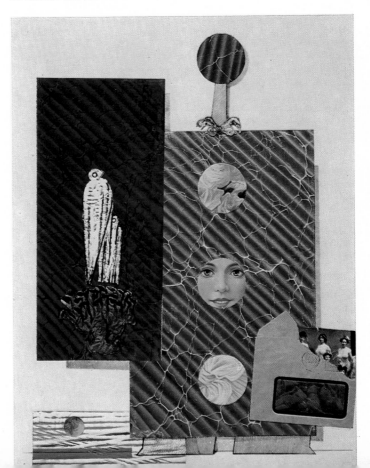

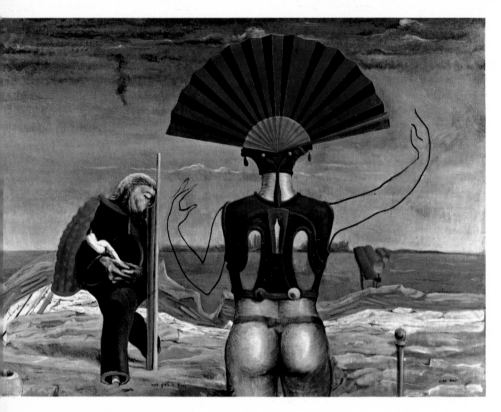

31
Femme, vieillard et fleur. 1924
Woman, Old Man and Flower

32
Pieta ou la révolution la nuit. 1923
Pieta or Revolution at Night

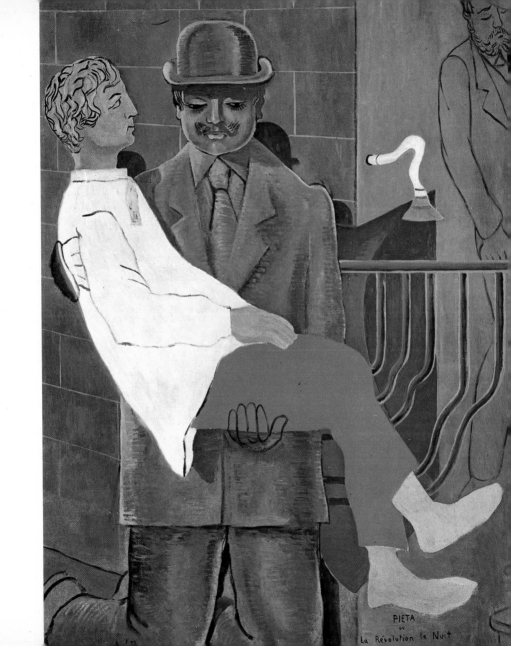

PIETA
ou
La Révolution le Nuit

33
L'Europe après la pluie
1942
Europe after the Rain

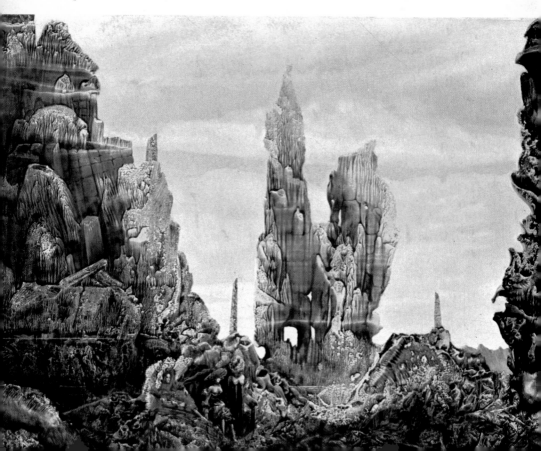

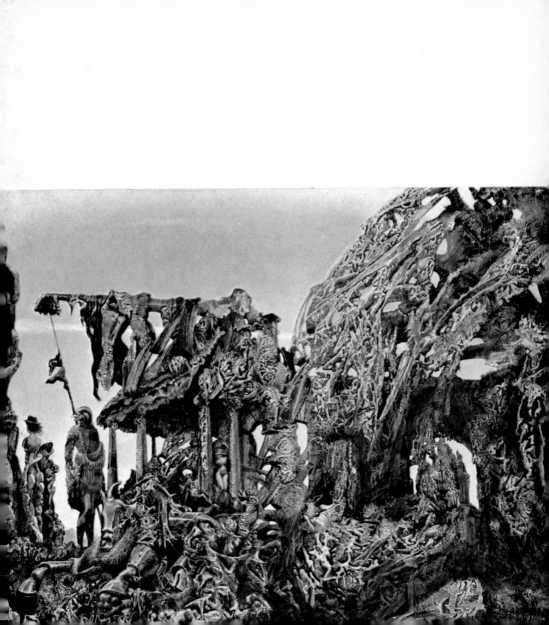

34
Vive la France
Long Live France

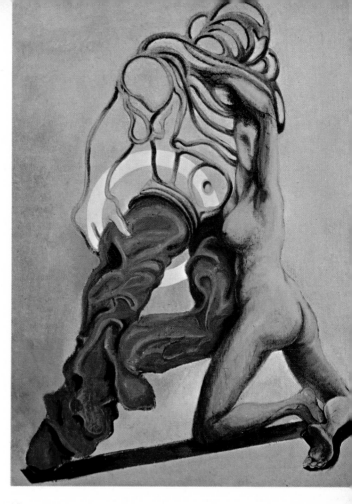

35
La Carmagnole de l'Amour

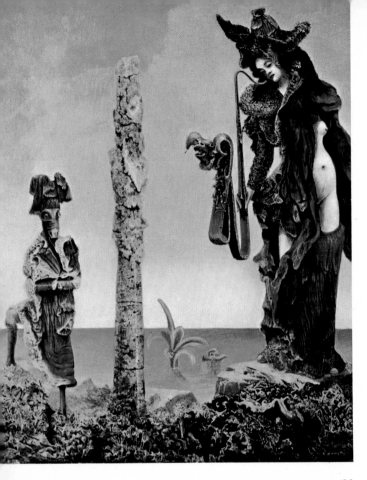

36
Napoléon dans le désert. 1941
Napoleon in the Desert

37
L'Antipape. Détail. 1942
The Antipope

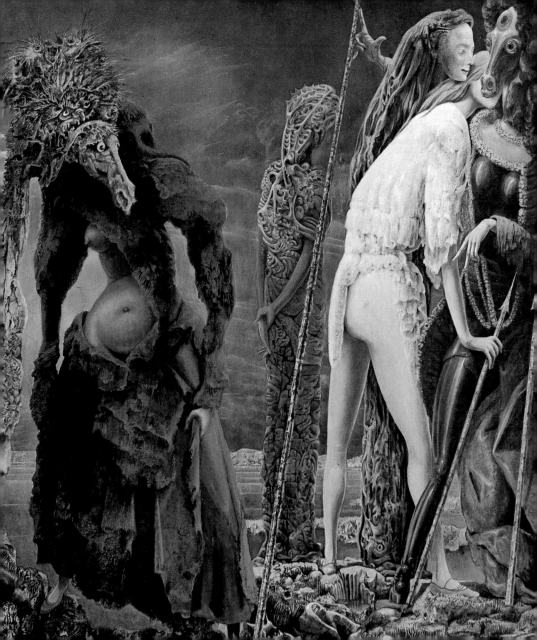

38
La fiancée du vent
1927
The Bride of the Wind

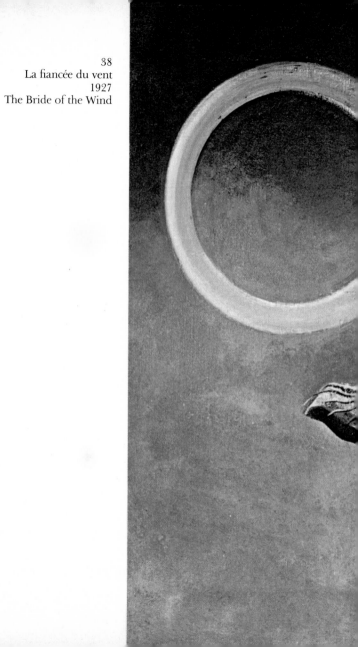

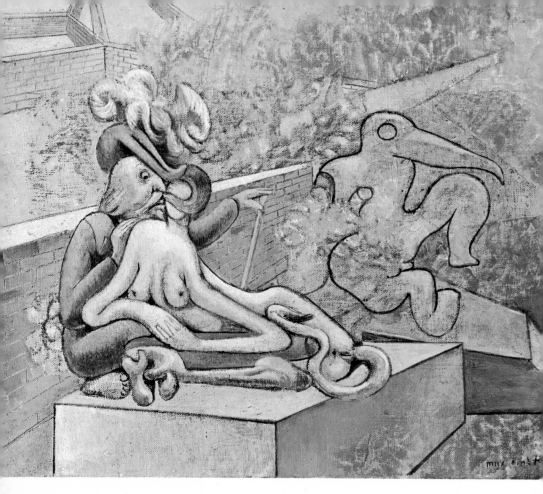

39
Henri IV, la lionne de Belfort
et un ancien combattant
1935
Henri IV, the Lioness of Belfort,
a Veteran

40
Deux jeunes filles nues
1926
Two Nude Girls

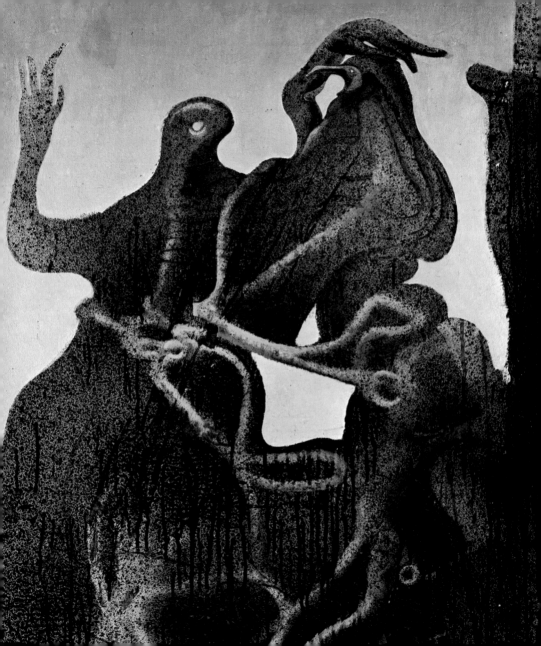

41
Couple zoomorphique
1933
Zoomorphic Couple

42
La Horde. 1927
The Horde

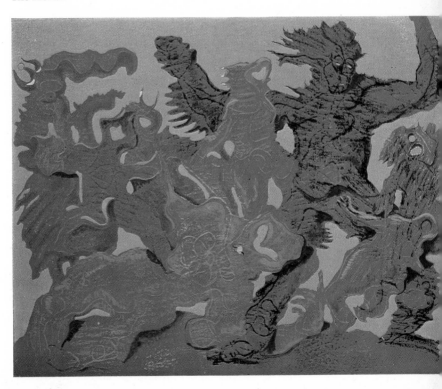

43
L'ange du foyer
1935
The Angel of Hearth and Home

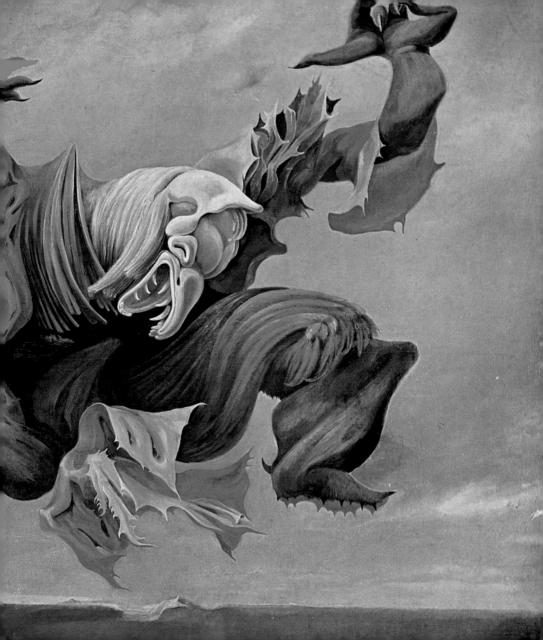

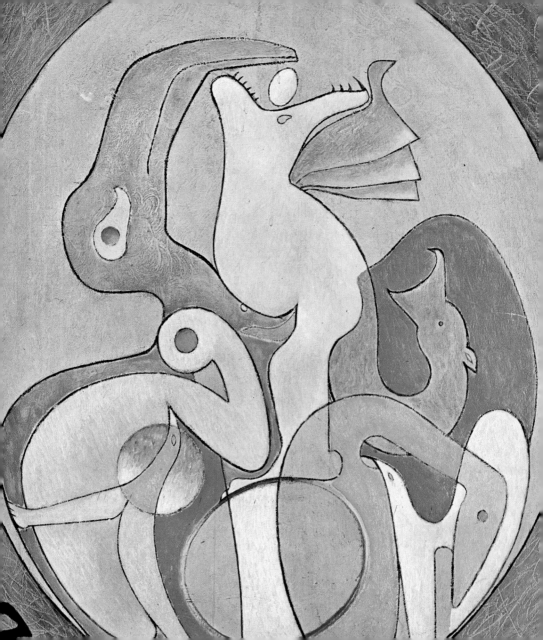

44
A l'intérieur de la vue : l'œuf
1929
The Interior of Sight (Egg)

45
Le jardin des Hesperides. 1936
The Garden of the Hesperides

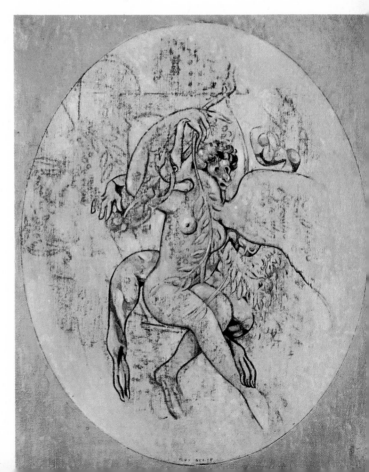

46
La ville entière
1937
The Entire City

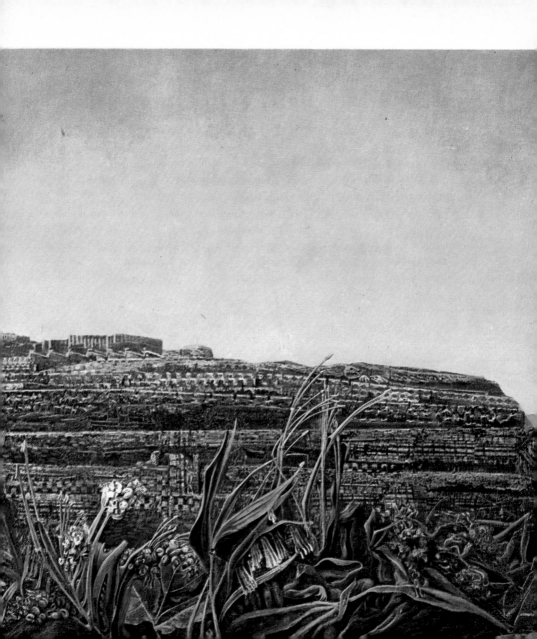

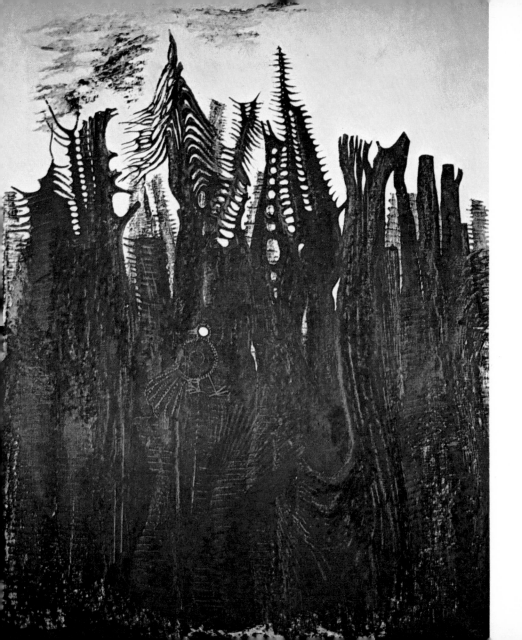

47
Forêt arêtes
1927
Fishbone Forest

48
Painting for Young People
1943

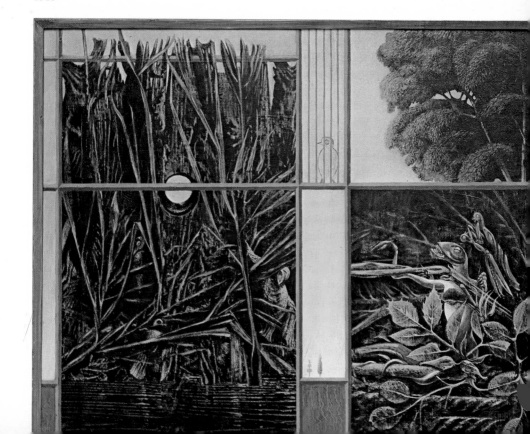

49
Nymphe écho
1936
The Nymph Echo

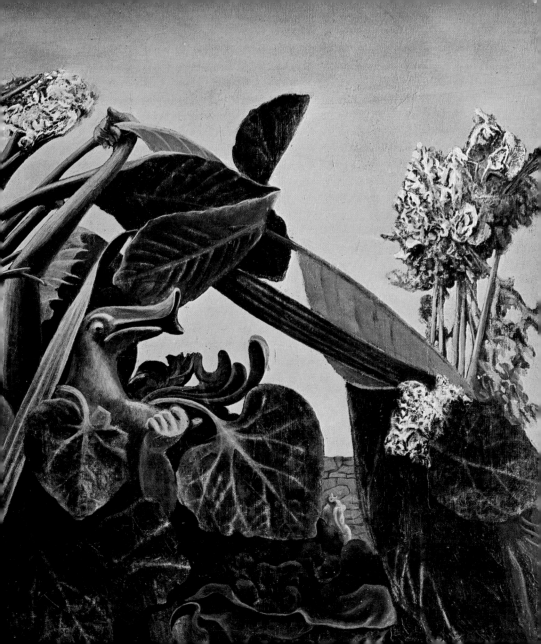

50
La tentation de Saint-Antoine
1945
Temptation of St-Anthony

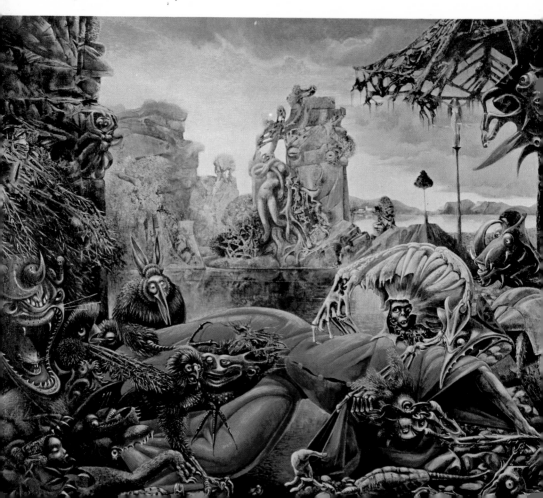

51
Nymphe écho
1936
The Nymph Echo

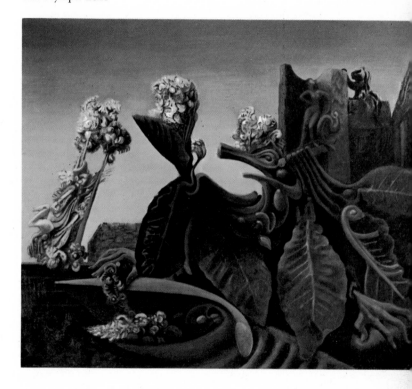

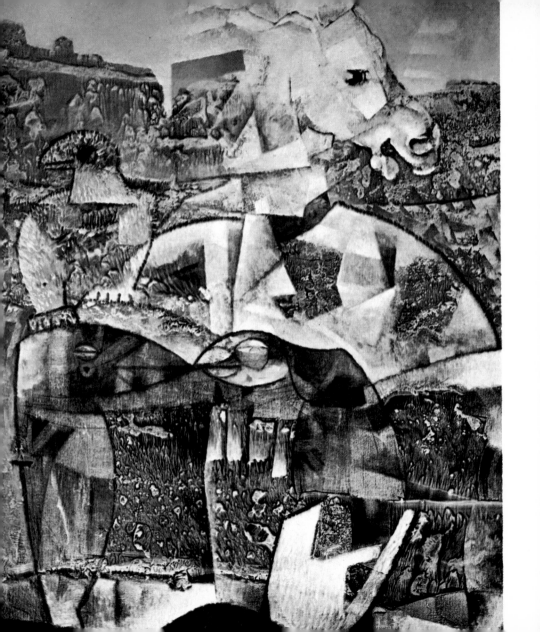

52
Cavalier polonais. 1954
The Polish Horseman

53
Oiseaux et océans. Détail. 1954
Birds and Oceans

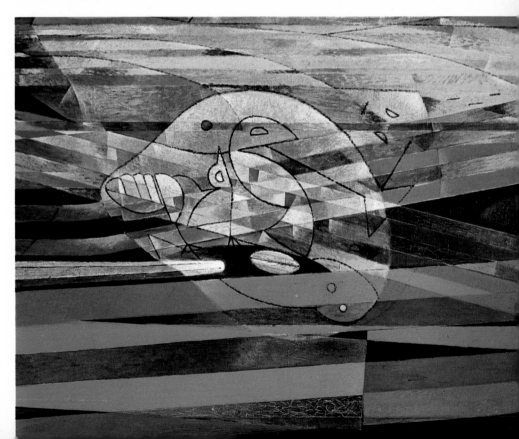

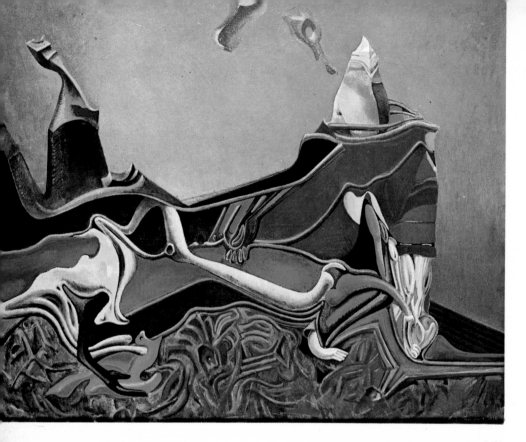

54
Paysage au germe de blé
1936
Landscape with Wheatgerm

55
It's Highway to Heaven
1956

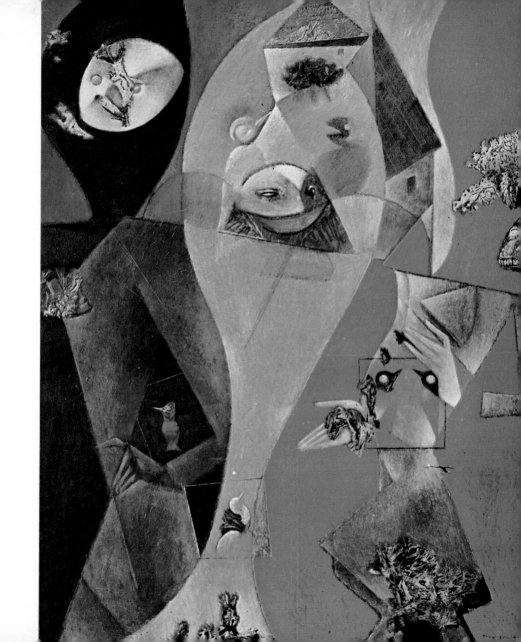

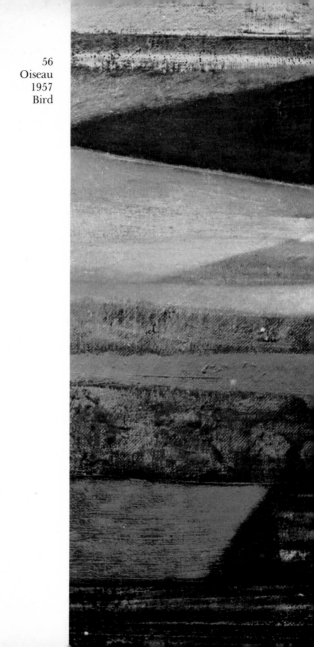

56
Oiseau
1957
Bird

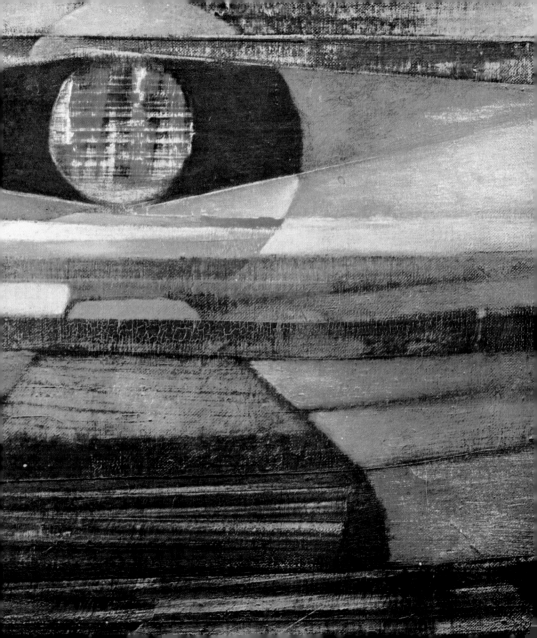

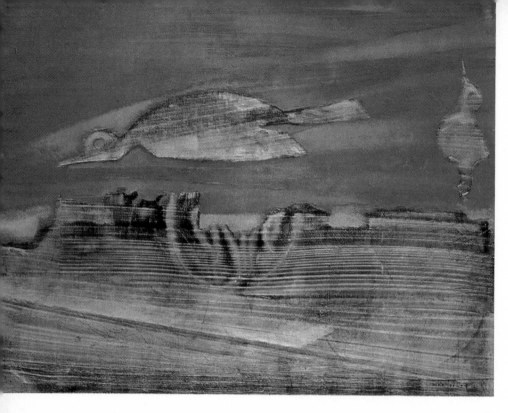

57
L'oiseau rose
1956
Pink Bird

58
Arizona rouge
1955
Red Arizona

59
Le jour et la nuit
1943
Day and Night

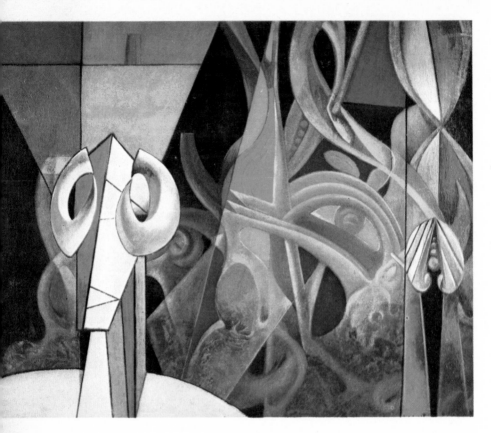

60
Design in Nature
1947

61
Euclide
1945
Euclid

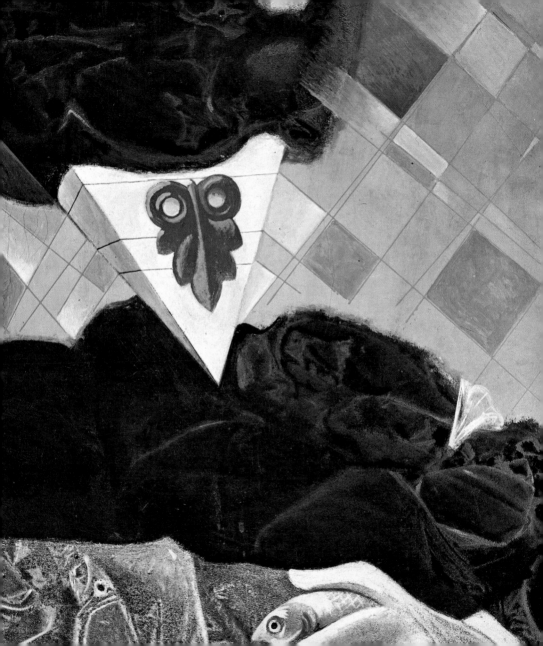

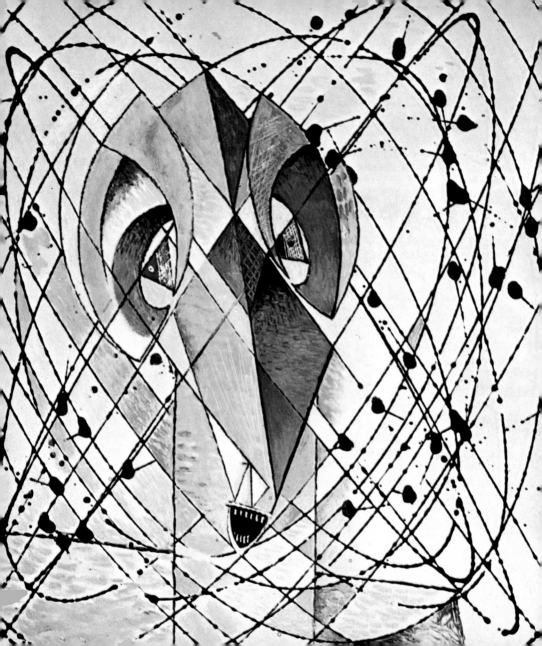

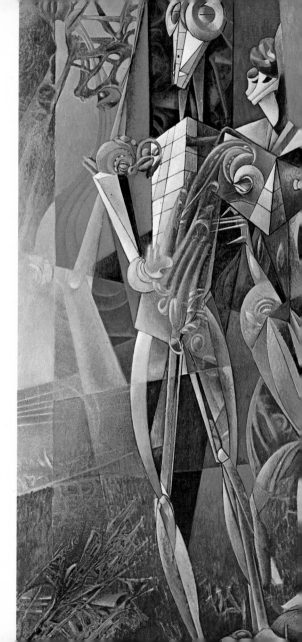

62
Tête d'homme intrigué
par le vol d'une mouche
non euclidienne
détail
Young Man Intrigued by the
Flight of a Non-Euclidean Fly

63
Les noces chimiques
1948
Chemical Nuptials

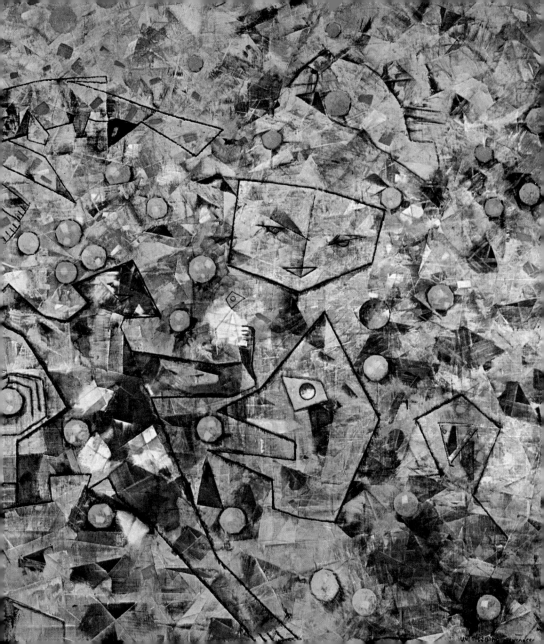

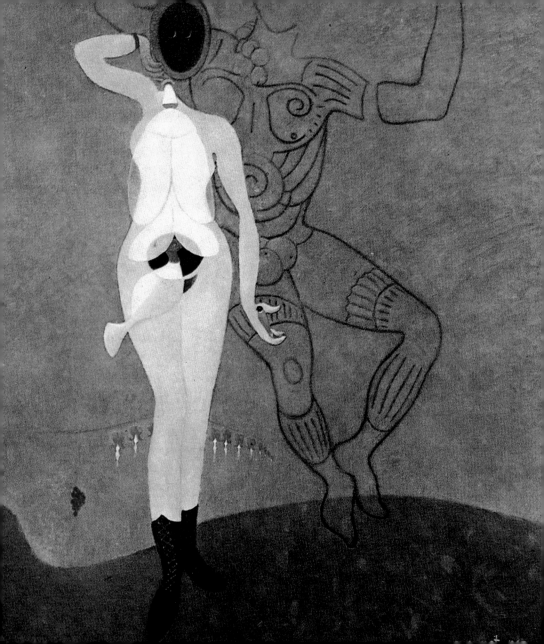

65
Le retour
de la belle jardinière. Détail.
1967
Return of the Fair Gardener

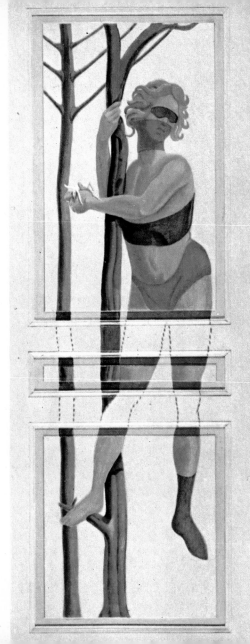

66
Entrer sortir
1923
Enter, Leave

67
Le XXᵉ siècle
1961
The 20th Century

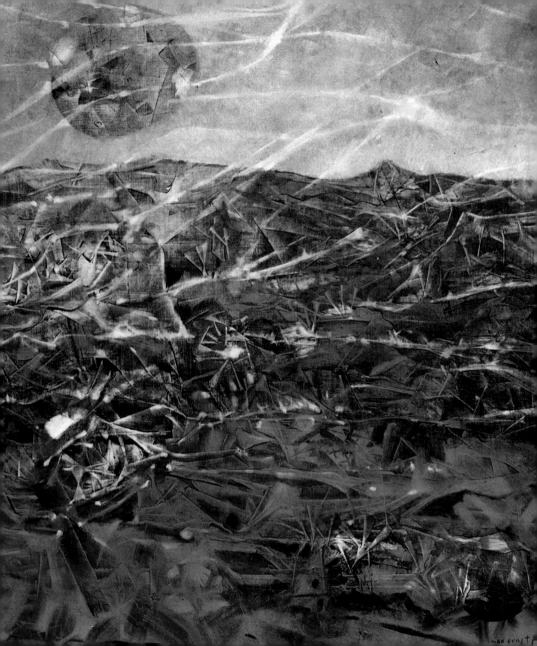

68
Le ciel épouse la terre
1964
Marriage of the Sky and the Earth

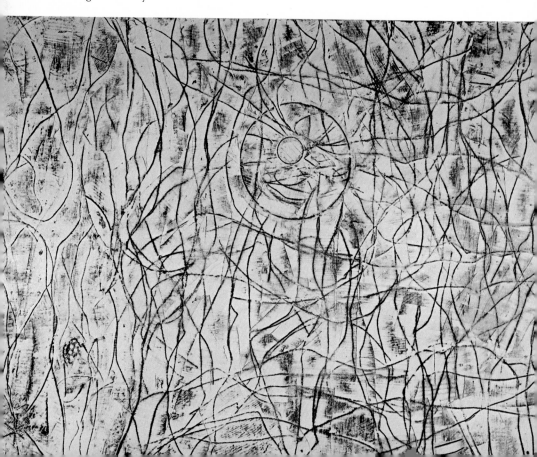

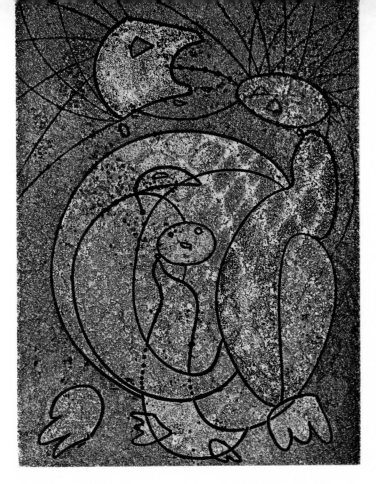

69
Eau-forte
Etching

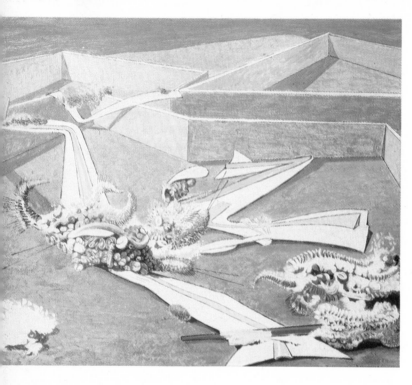

70
Jardin gobe-avions
1935
Garden Plane-Trap

71
Nymphéa
1956
Nymphea

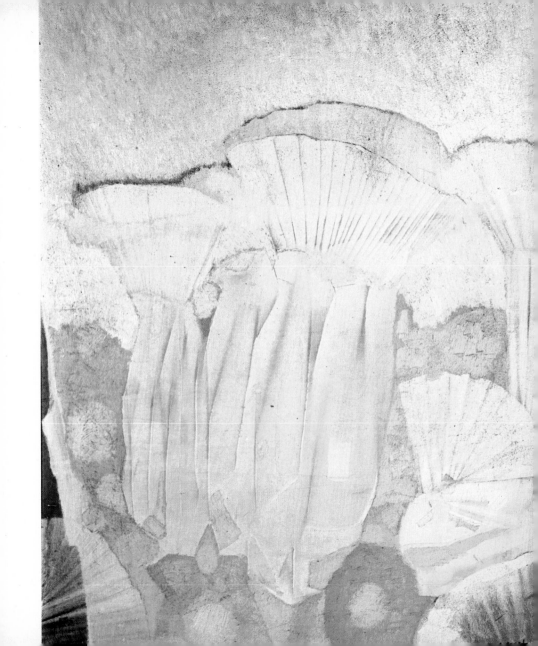

72
Un peu de calme
détail
A Little Calm

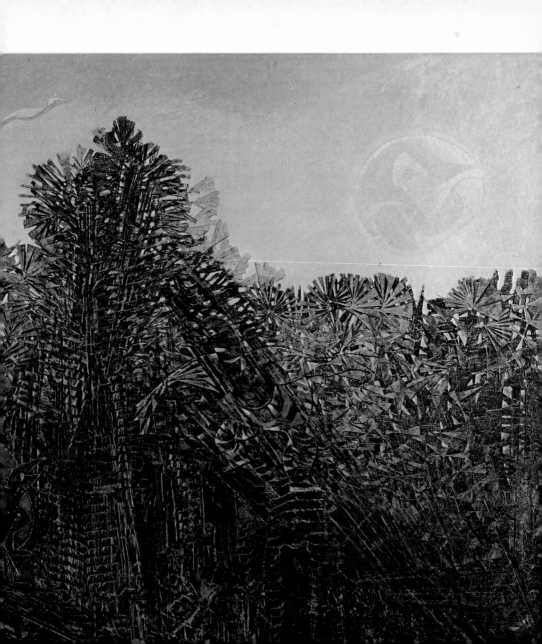

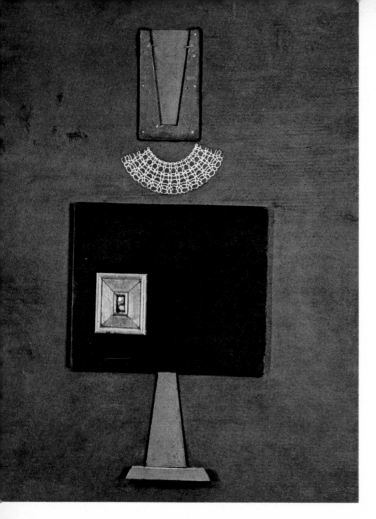

73
Portrait d'ancêtre. 1965. Ancestral Portrait

74
Maison en feu et ange en tablier blanc. 1965
House on Fire and Angel in a White Apron

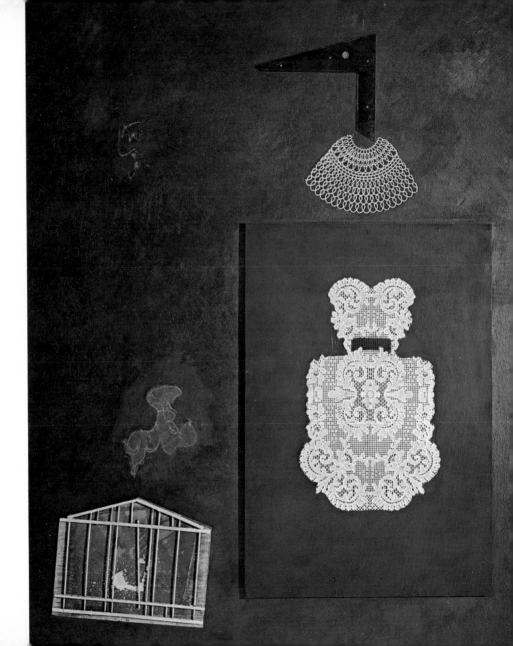

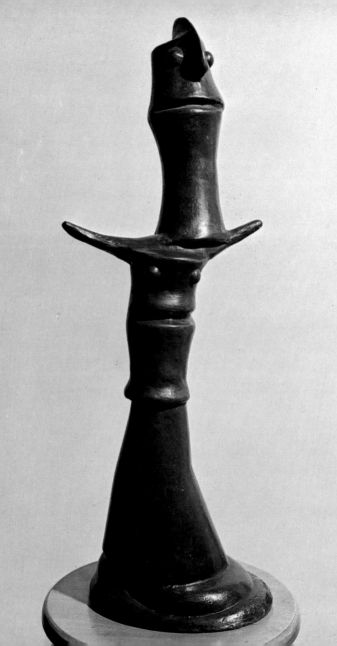

75
Oedipe. 1934
Oedipus

76
Jeune femme en forme de fleur. 1944
Young Woman in the Shape of a Flower

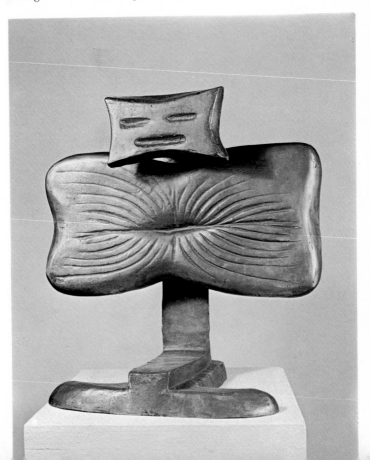

78 ▶
Max Ernst
(Photo A. Morain)

77
Ici meurent les cardinaux
1962
The Cardinals Die Here

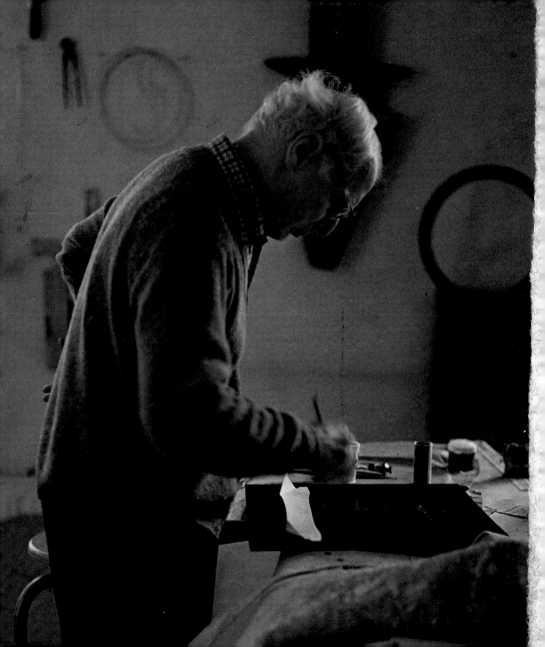